ART IS...

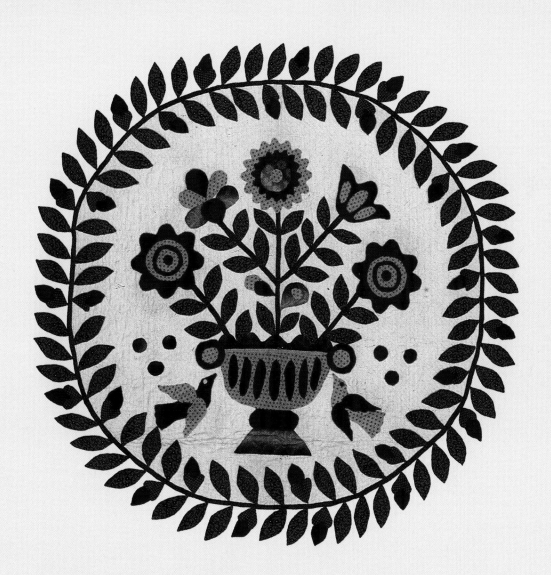

BY BOB RACZKA

THE MILLBROOK PRESS

BROOKFIELD, CONNECTICUT

TO ROBERT, CARL, AND EMMA, EACH ONE A PIECE OF WORK

Copyright © 2003 by Bob Raczka

Library of Congress Cataloging-in-Publication Data
Raczka, Bob.
 Art is... / by Bob Raczka.
 p. cm.
Summary: Rhyming text and photographs show that art
is much more than just what can be hung on a wall or set
on a pedestal.
ISBN 0-7613-2874-2 (lib.) -- ISBN 0-7613-1832-1 (pbk.)
1. Art appreciation--Miscellanea--Juvenile literature.
[1. Art appreciation.] I. Title.
 N7440.R33 2003
 701--dc21

2002011267

Published by The Millbrook Press, Inc.
2 Old New Milford Road
Brookfield, Connecticut 06804
www.millbrookpress.com

Designed by Tania Garcia
Picture research by Pam Szen

Manufactured in China

5 4 3 2 1 (lib.)
5 4 3 2 1 (pbk.)

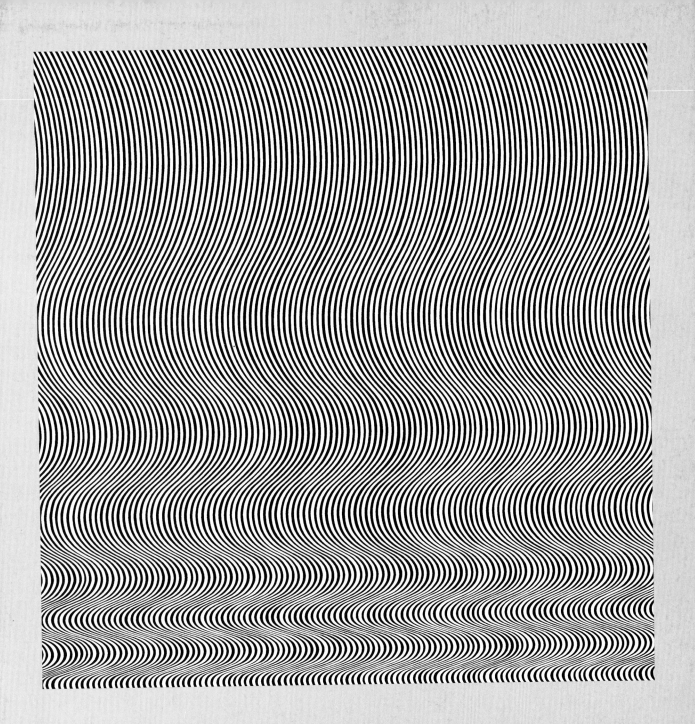

ART IS LINES.

FALL
Bridget Riley
1963
Tate Gallery, London

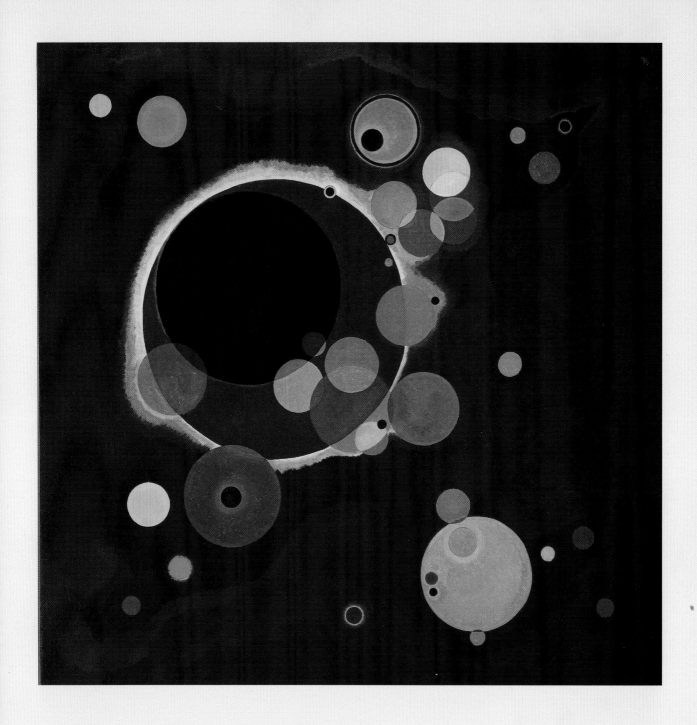

ART IS SHAPES.

SEVERAL CIRCLES
Wassily Kandinsky
1926
Solomon R. Guggenheim Museum, New York

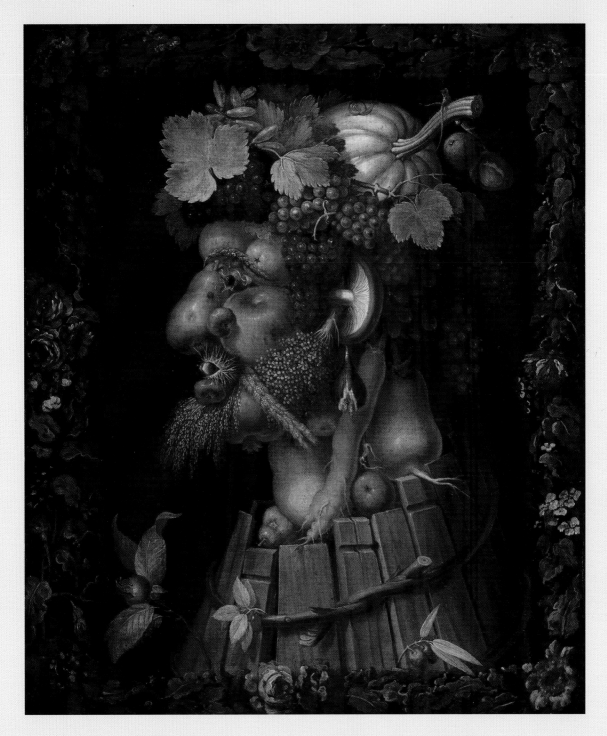

ART IS A FACE MADE
WITH APPLES AND GRAPES.

L'AUTUNNO (AUTUMN)
Giuseppe Arcimboldo
1573
Musée du Louvre, Paris

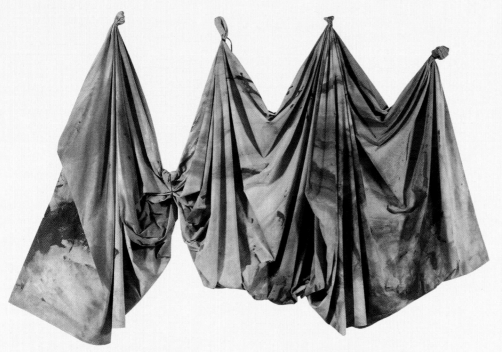

ART IS DRAPED.

RELATIVE
Sam Gilliam
1969
National Gallery of Art, Washington, D.C

ART IS CHISELED.

HEAD
Amedeo Modigliani
1911-13
Solomon R. Guggenheim Museum, New York

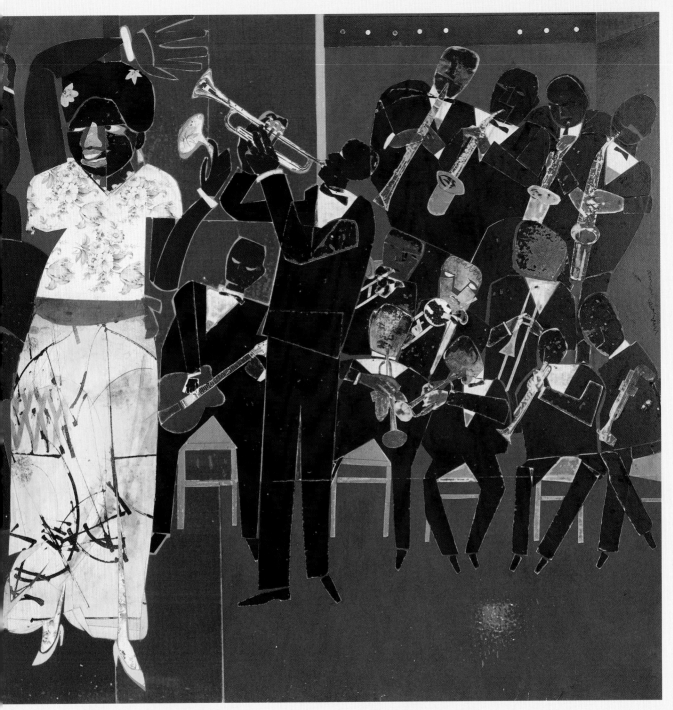

ART IS PASTED.

EMPRESS OF THE BLUES
Romare Bearden
1974
Smithsonian American Art Museum, Washington, D.C.

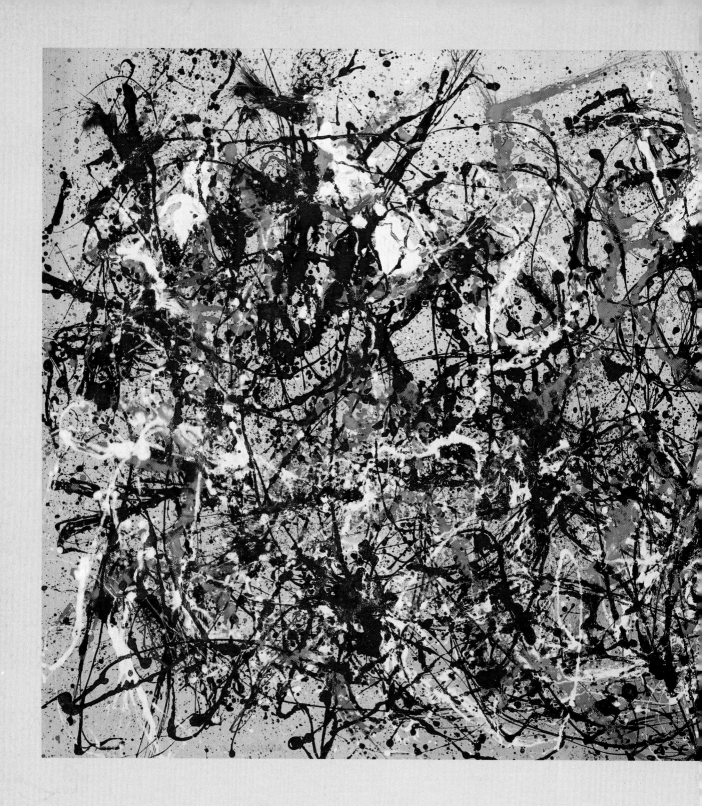

8

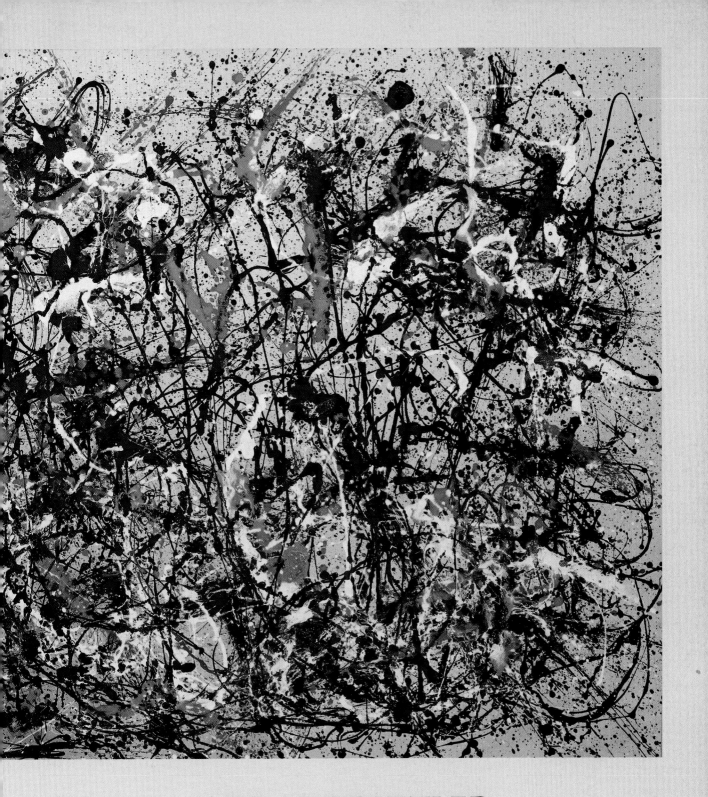

ART IS DRIZZLED.

AUTUMN RHYTHM (NUMBER 30)
Jackson Pollock
1950
The Metropolitan Museum of Art, New York

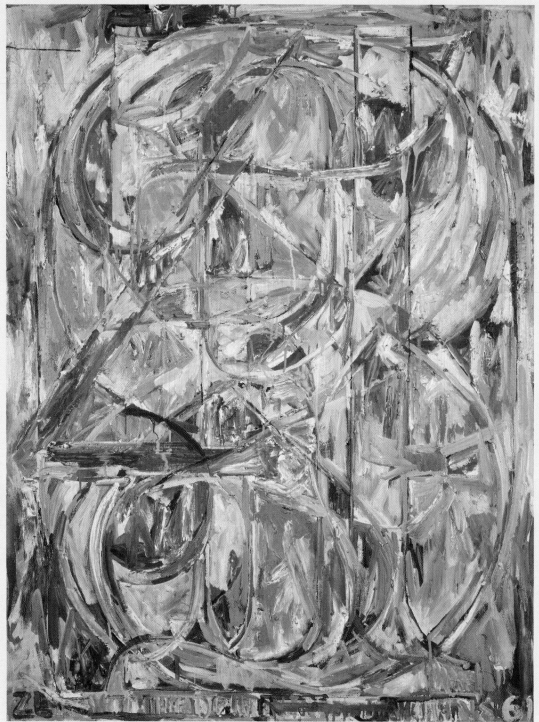

ART IS A NUMBER.

ZERO THROUGH NINE
Jasper Johns
1961
Tate Gallery, London

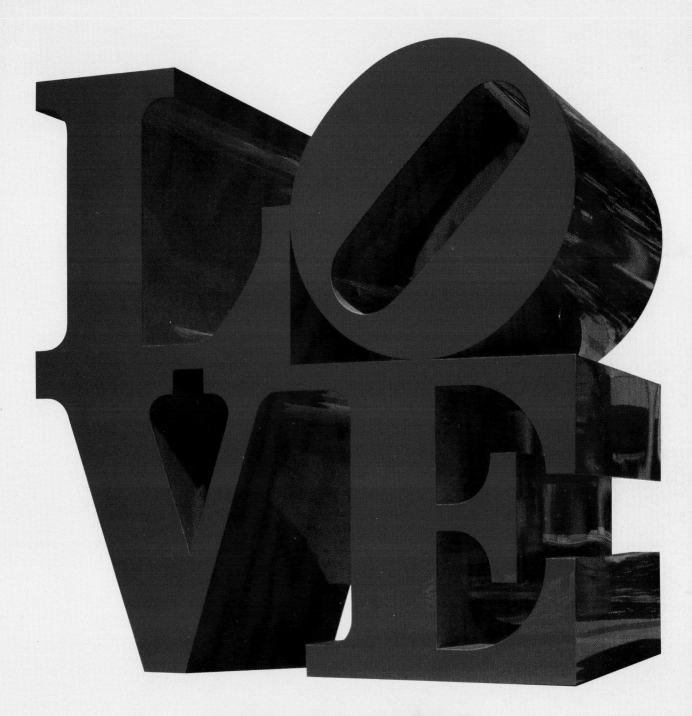

ART IS A WORD.

LOVE
Robert Indiana
1966–1993
Shinjuku-I-Land Public Art Project, Tokyo, Japan

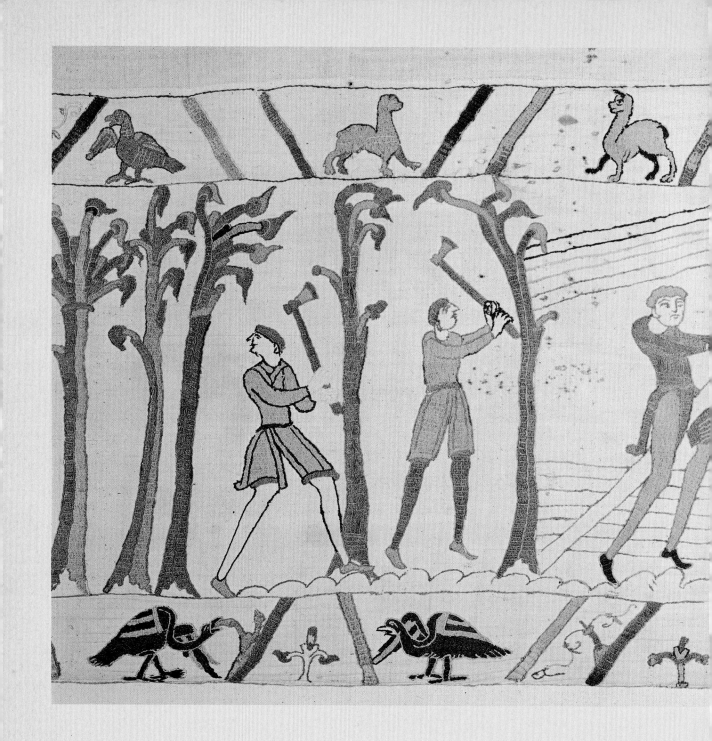

ART IS A RECORD

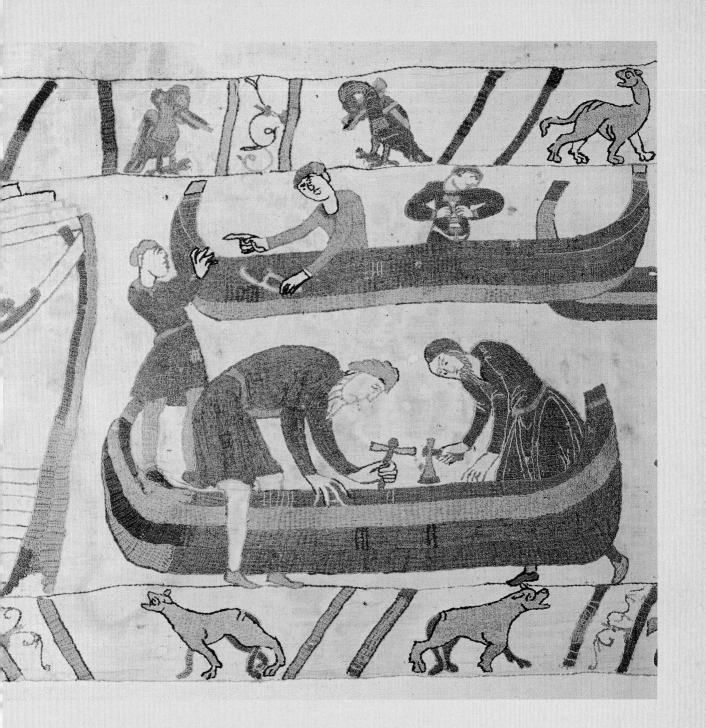

OF WHAT HAS OCCURRED.

THE BAYEUX TAPESTRY
Artist Unknown
c. 1070s
Musée de la Tapisserie, Bayeux, France

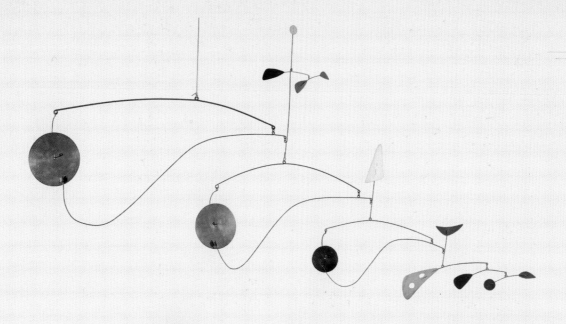

ART IS MOVING.

TRIPLE GONG
Alexander Calder
1948
Private Collection

ART IS DARING.

THE TIGHTROPE WALKER
George Segal
1969
Carnegie Museum of Art, Pittsburgh

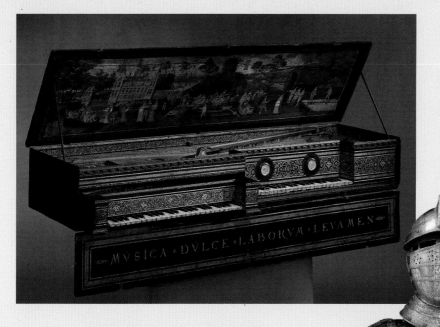

ART IS FOR PLAYING.

DOUBLE VIRGINAL
Hans Rucker the Elder
1581
The Metropolitan Museum of Art,
New York

ART IS FOR WEARING.

THREE-QUARTER FIELD ARMOR
1570–1580
The George F. Harding Collection,
The Art Institute of Chicago

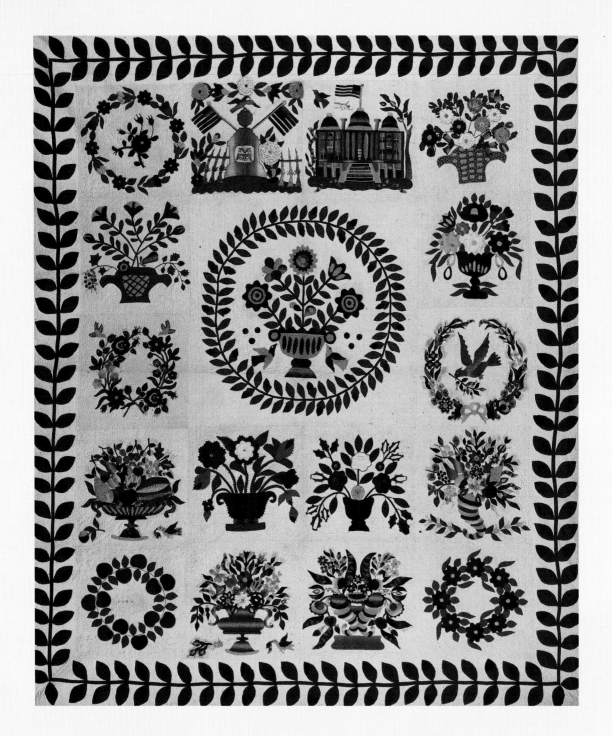

ART IS A HAND-CRAFTED
WAY TO STAY WARM.

APPLIQUÉD QUILT
Sarah Anne Whittington Lankford,
possibly with family and friends
c. 1850
Abby Aldrich Rockefeller Folk Art Center, Williamsburg, Virginia

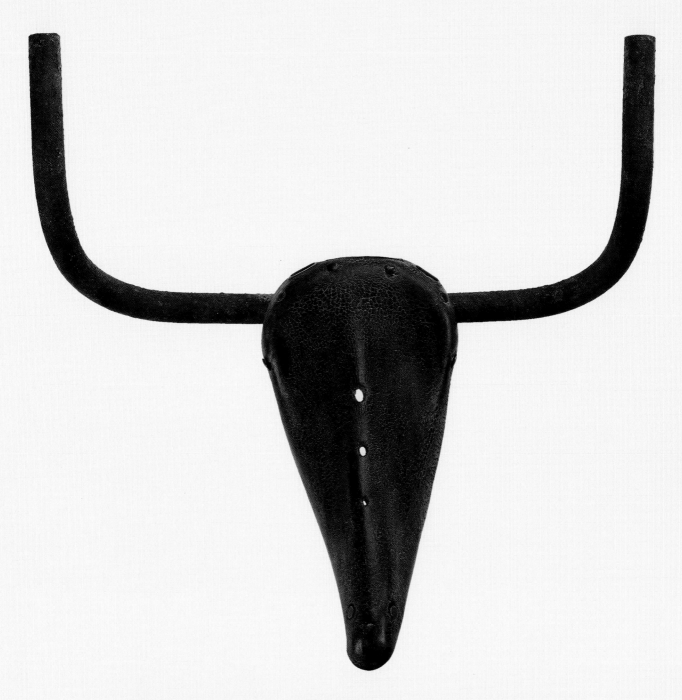

ART IS AN OLD THING THAT TAKES A NEW FORM.

BULL'S HEAD
Pablo Picasso
1942
Musée Picasso, Paris, France

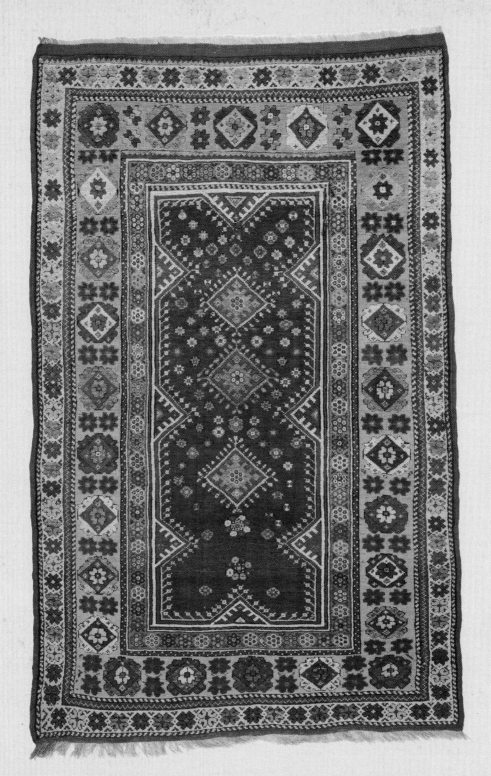

ART IS TO KNEEL ON.

PRAYER RUG FROM MILAS, ANATOLIA
1850-1900
Harvard University Art Museums, Cambridge, Massachusetts

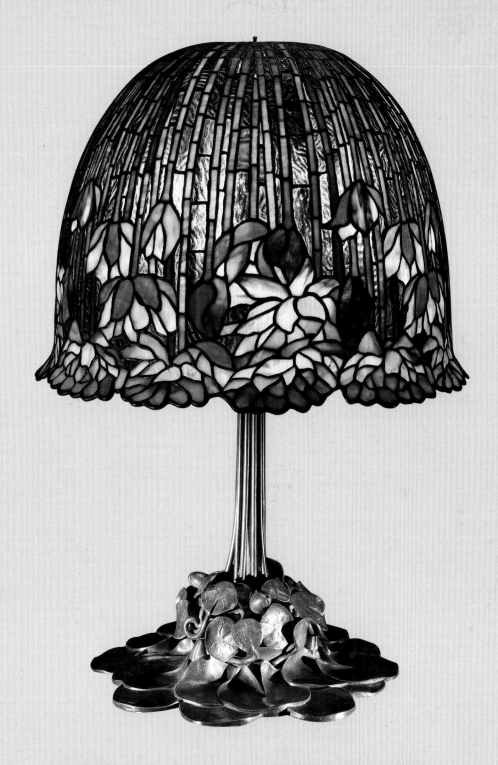

ART IS ENLIGHTENING.

WATER LILY TABLE LAMP
Louis Comfort Tiffany
1904-1915
The Metropolitan Museum of Art, New York

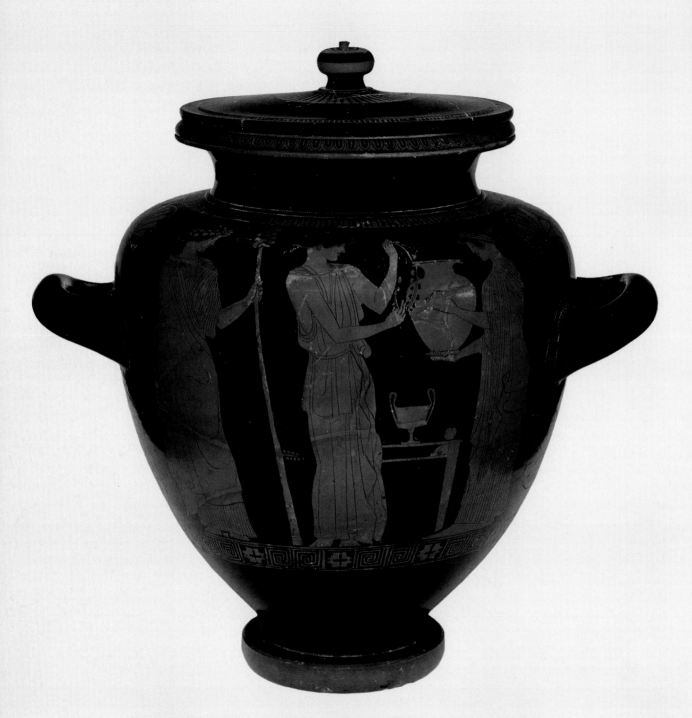

ART IS TO DRINK FROM.

GREEK WINE VESSEL
c. 450 B.C.
The Art Institute of Chicago

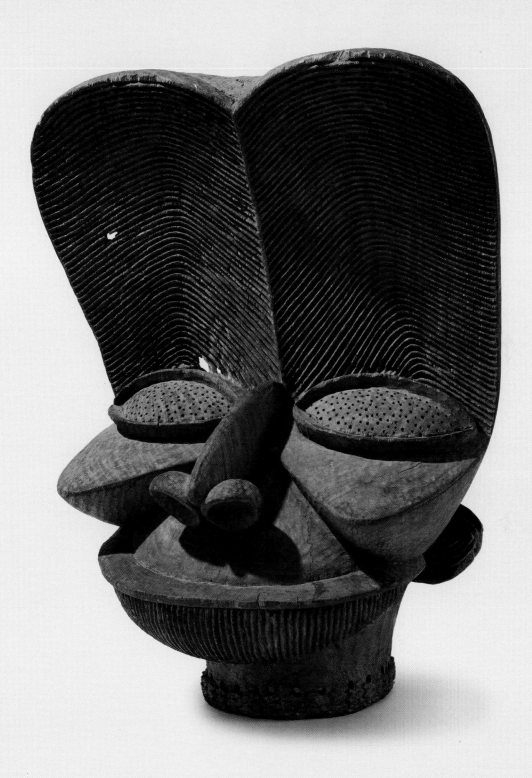

ART IS FRIGHTENING.

MASK FROM THE BAMENDA AREA, CAMEROON
19th-20th century
Rietberg Museum, Zurich

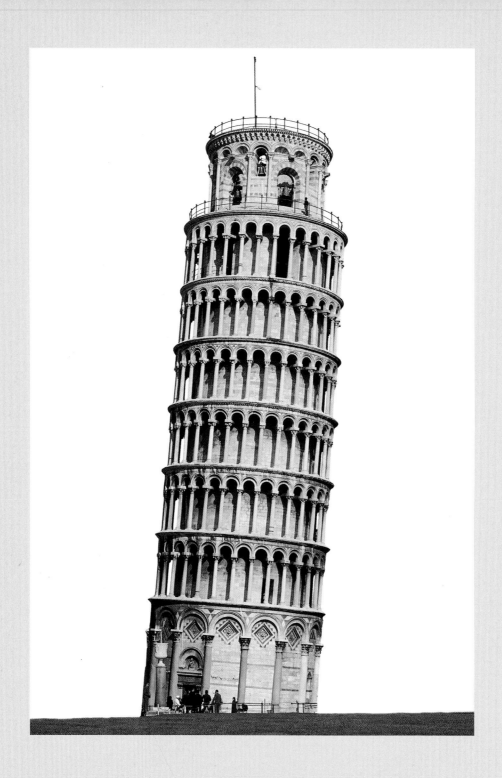

ART IS A TOWER THAT ISN'T QUITE STRAIGHT.

LEANING TOWER OF PISA
Attributed to Bonanno Pisano
late 12th century
Pisa, Italy

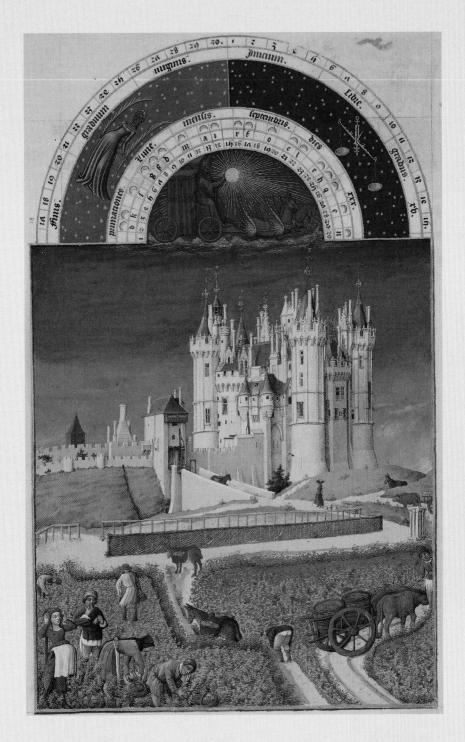

ART IS A WAY TO KEEP TRACK OF THE DATE.

TRÈS RICHES HEURES DU DUC DE BERRY (THE BOOK OF HOURS)
The Limbourg Brothers
1416
Musée Condé, Chantilly, France

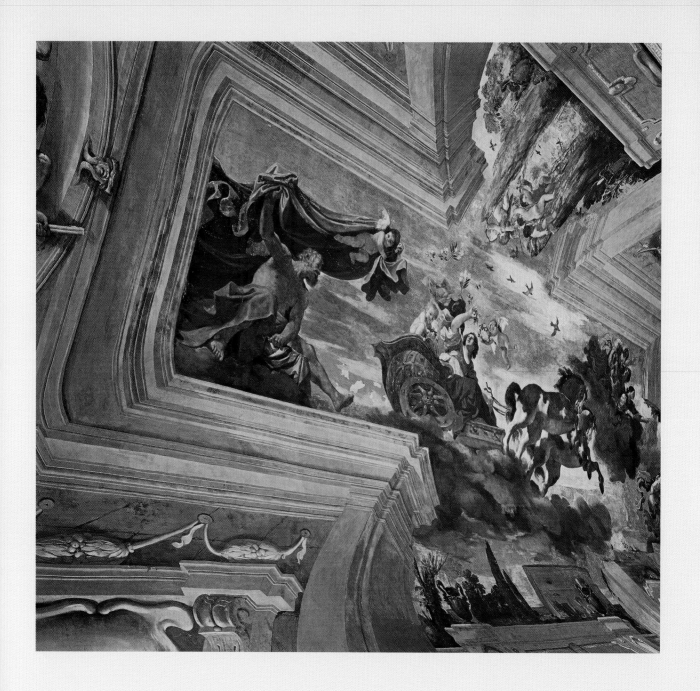

ART IS A CEILING.

AURORA
Giovanni Francesco Guercino
1621-23
Casino Ludovisi, Rome

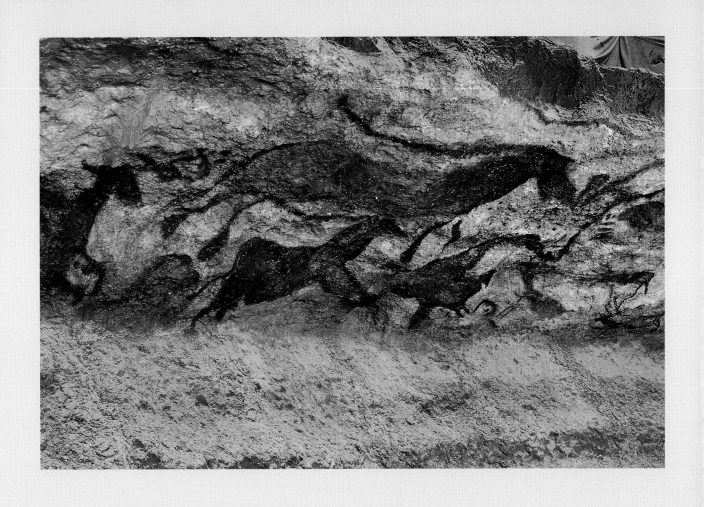

ART IS A WALL.

LASCAUX CAVE PAINTINGS
15,000 B.C.
Lascaux, France

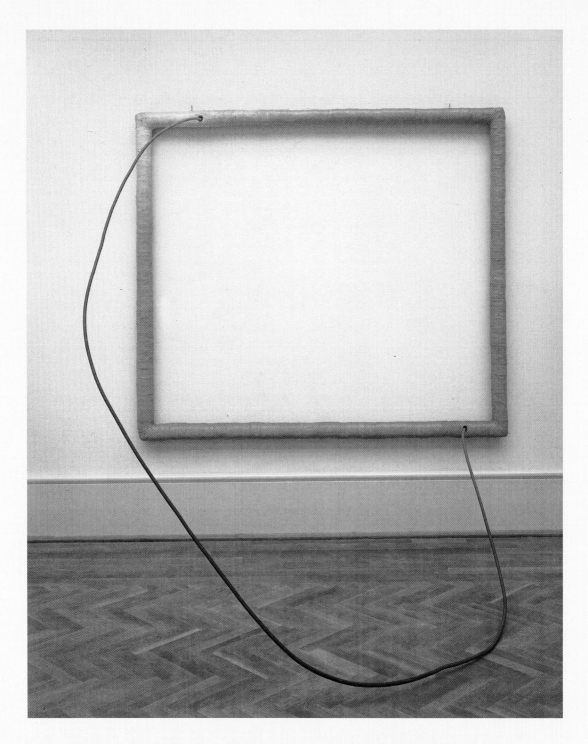

ART IS A FRAME HOLDING NOTHING AT ALL.

HANG UP
Eva Hesse
1966
Art Institute of Chicago

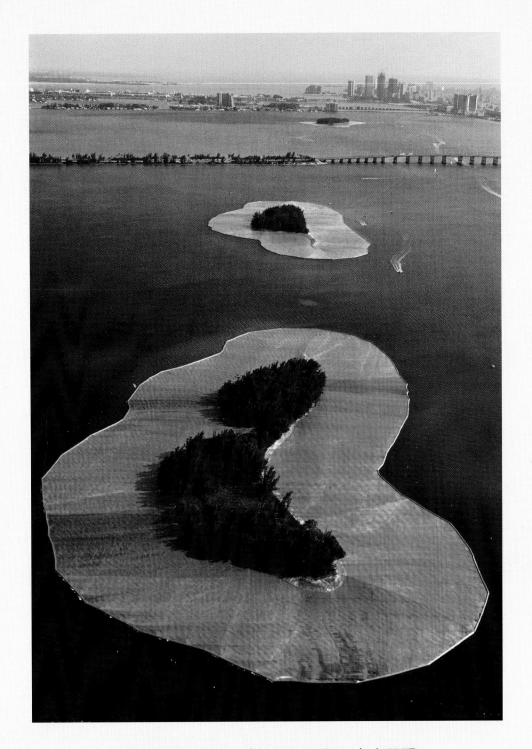

ART IS AN ISLAND
SURROUNDED BY PINK.

SURROUNDED ISLANDS
Christo Javacheff & Jeanne-Claude de Guillebon
1980-83
Biscayne Bay, Miami, Florida

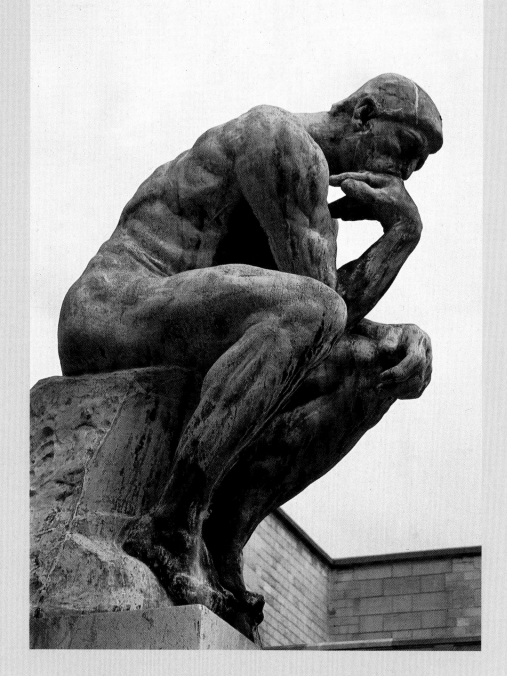

ART IS HOW ARTISTS GET YOU TO THINK.

THE THINKER
Auguste Rodin
c. 1910
Musée Rodin, Paris, France

NOTES

BRIDGET RILEY (1931–) BRITISH

Because they play tricks on your eyes, Bridget Riley's paintings are called Op Art. "Op" is short for "Optical."

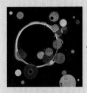

WASSILY KANDINSKY (1866–1944) RUSSIAN

Wassily Kandinsky decided to become an abstract painter when he saw one of his own paintings upside down—and liked it better that way.

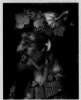

GIUSEPPE ARCIMBOLDO (1527–1593) ITALIAN

In addition to making faces out of fruits and vegetables, Giuseppe Arcimboldo created portraits out of books, tools—even pots and pans.

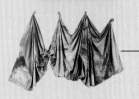

SAM GILLIAM (1933–) AFRICAN AMERICAN

Early in his career, Sam Gilliam stopped using frames and started draping, bunching, and shaping his painted canvases, treating them more like sculpture.

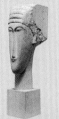

AMEDEO MODIGLIANI (1884–1920) ITALIAN

When he lived in Paris, Amedeo Modigliani was so poor that he scavenged stone for his sculptures from local building sites.

ROMARE BEARDEN (1911–1988) AFRICAN AMERICAN

After struggling to find a style of his own, Romare Bearden mastered the art of collage. He pasted pieces of fabric, paper, and other materials into his work.

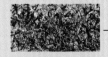

JACKSON POLLOCK (1912–1956) AMERICAN

Because Jackson Pollock often dripped and drizzled paint onto his canvases, he was given the nickname, "Jack the Dripper."

JASPER JOHNS (1930–) AMERICAN

Jasper Johns once said, "To be an artist you have to give up everything, including the desire to be a good artist."

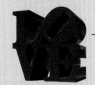

ROBERT INDIANA (1928–) AMERICAN

Because most people take words and numbers for granted, Robert Indiana said his job as an artist is "to make words and numbers very, very special."

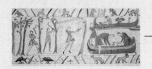

BAYEUX TAPESTRY (C. 1070S) NORMANDY, FRANCE

The Bayeux Tapestry is a woven record of the historic Battle of Hastings in 1066. It is 230 feet (70 meters) long.

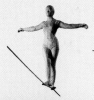

ALEXANDER CALDER (1898–1975) AMERICAN

When Alexander Calder invented sculptures that could move and change with a breath of wind, he didn't have a name for them. It was his friend who first called them "mobiles."

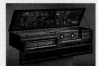

GEORGE SEGAL (1924–) AMERICAN

To make his sculptures, George Segal often used his family, friends, or neighbors as models. He would wrap them in wet plaster, removing it only after it dried.

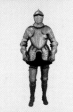

HANS RUCKER THE ELDER (C. 1545–1598) FLEMISH

A double virginal is an instrument related to the piano, except it has two keyboards—a larger one called "the mother," and a smaller one called "the child."

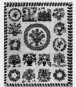

SUIT OF ARMOR (C. 1570S) ITALIAN

This suit of armor, called a *garniture*, is made of pieces that could be added or removed, depending on whether it was used for combat or for sporting contests.

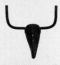

SARAH ANNE WHITTINGTON LANGFORD (1830–1898) AND OTHERS (19TH CENTURY) AMERICAN

Although making a quilt was a way for them to express themselves artistically, American pioneer women probably thought of quiltmaking as a practical activity.

PABLO PICASSO (1881–1973) SPANISH

When most people look at a bicycle seat and handlebars, they see a bicycle seat and handlebars. Pablo Picasso saw the head of a bull.

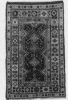

RUG (1850–1900) FROM MILAS, TURKEY

This prayer rug, or *sejjadeh*, was made in the village of Milas, Anatolia. Milas rugs are known for their earthy colors like orange-red, gold and deep purple.

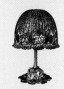

LOUIS COMFORT TIFFANY (1848–1933) AMERICAN

Although he is best known as a designer of stained glass lamps, Louis Comfort Tiffany started out as a painter.

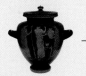

WINE VESSEL (C. 450 B.C.) GREEK

This wine jar, or *stamnos*, was decorated using the red-figure technique. The pictures were left in the natural red color of the clay and surrounded by black glaze.

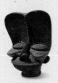

MASK (19TH-20TH CENTURY) AFRICAN

Expertly carved from a large piece of wood, this African mask is amazingly symmetrical—the facial features on the left side are exactly the same as those on the right.

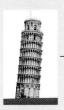

ATTRIBUTED TO BONANNO PISANO
(ACTIVE LATE 12TH CENTURY) ITALIAN

Due to wars with neighboring cities, the Leaning Tower of Pisa took 177 years to complete, from 1173 to 1350. It leans more than 17 feet (5 meters) from top to bottom.

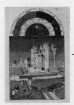

THE LIMBOURG BROTHERS (JEAN, HERMANN,
AND PAUL) (ACTIVE C. 1400) GERMAN

During the Middle Ages, a Book of Hours was both a prayer book and calendar. This page for September shows peasants harvesting grapes, with the days and the prominent constellations across the top.

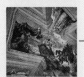

GIOVANNI FRANCESCO GUERCINO (1591-1666) ITALIAN

By painting the undersides of the clouds, and the horses and chariot, Guercino created the illusion that we are standing under Aurora as she is being pulled across the sky.

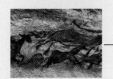

CAVE PAINTINGS (C. 15,000 B.C.) FRENCH

The prehistoric cave paintings at Lascaux were discovered in 1940 by four boys looking for a dog, which had fallen into one of the cave openings.

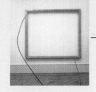

EVA HESSE (1936-1970) GERMAN

Although she was a woman, Eva Hesse did not want people to think of her art as "women's art." According to Eva, "Excellence has no sex."

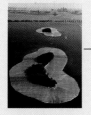

CHRISTO JAVACHEFF (1935-) AMERICAN (BORN IN
BULGARIA), JEANNE-CLAUDE DE GUILLEBON (1935-) MOROCCAN

For two weeks in 1983, Christo and his wife surrounded 11 islands off the coast of Miami with woven pink fabric—6.5 million square feet (585,000 square meters) of it.

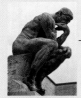

AUGUSTE RODIN (1840-1917) FRENCH

The École des Beaux-Arts, the official art school of France, rejected the young Auguste Rodin not just once, but three times.